PICASSO'S ONE-LINERS

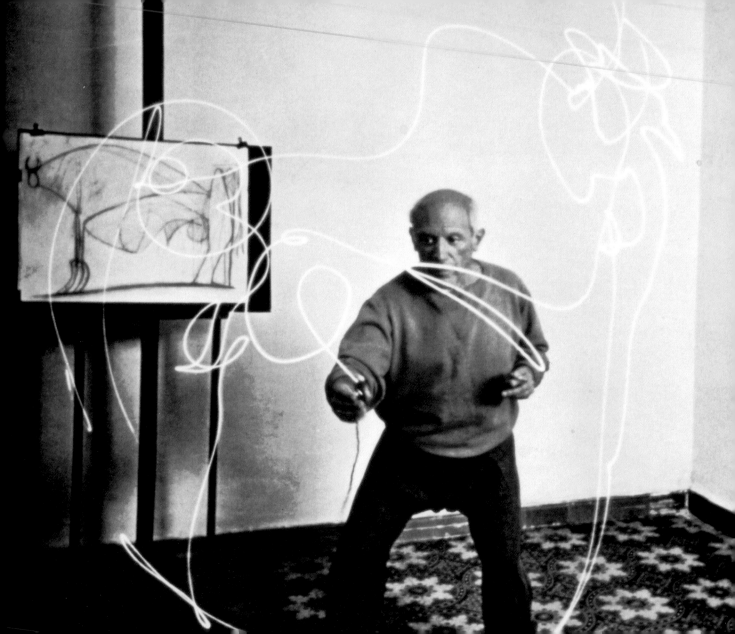

PiCaSsO'S

ONE-LINERS

INTRODUCTION BY

SUSAN GRACE GALASSI

ARTISAN NEW YORK

CONCEPT, DESIGN, AND ILLUSTRATION SELECTION BY DENNIS AND SUSAN FEIGENBAUM

Jacket design: Alexandra Maldonado
Production director: Hope Koturo

Library of Congress Cataloging-in-Publication Data
Picasso, Pablo, 1881–1973
Picasso's one-liners / with an introduction by Susan Galassi.
p. cm.
ISBN 1–885183–78–X
1. Picasso, Pablo, 1881–1973--Themes, motives. I. Title.
NC248.P5A4 1997
741.944--dc21 97-3776
CIP

Published in 1997 by Artisan,
a Division of Workman Publishing Company, Inc.
708 Broadway, New York, NY 10003

Printed in Singapore
10 9 8 7 6 5 4 3 2 1
First Printing

If I had to choose among all his works, I would choose the

drawings without a moment's hesitation.... It is through his feverish pen

that his personality can display itself without the least constraint.

HENRI MICHAUX

Open this book to any page and pick up Picasso's line at the beginning and follow it through to the end. Its fluid movement, as supple and acrobatic as the figures that seem to leap from the page, takes us on a delightful journey. We follow the artist's thought process as it is transmitted to the motion of his hand and pressed on paper in a single masterful stroke. Freedom of gesture, sureness of hand, and a genius for capturing the essence of a character through movement, are integral to these deceptively simple, whimsical drawings.

All the works collected here are composed from one continuous flowing line: the artist touches the paper with his implement, and does not lift it again until the image is completed. Picasso took evident pleasure in this challenging exercise—part doodle, part virtuoso performance—and experimented with it in pen and ink, pencil, crayon, and brush and watercolor at intervals throughout his life, and even, on one occasion, drawing with light (see frontispiece). Yet little attention has been paid to this special genre of Picasso's drawings. Most likely he drew them for his own amusement, or as jeux d'esprit to share with his friends; still, he saved them as he did all his works on paper, and many are preserved today in the Musée Picasso in Paris. Like the quotes that accompany these images, these abbreviated creations have a direct, off-the-cuff quality, which nevertheless reward close attention. In their spontaneity and irrepressibility, these small tours-de-force underline important characteristics of Picasso's drawing in general: his deep involvement in process, the central role of play, his emphasis on discovery, and, above all, his endless fascination with the expressive power of line.

Most of these were executed in multiple versions, indicating that it was the pleasure of the very process of drawing and the infinite range of permutations of line that held Picasso's interest, rather than a single solution to a problem. Some of the drawings were used as illustrations for his friends' books; many of them are connected with his theater projects of the post–World War I period, and some are independent creations, but all of them are revealing of the role of drawing at the various stages of his career. The subjects—figures, either single or in pairs, and animals—appear throughout his art. Many are performers: harlequins and Pierrots of the *commedia dell'arte,* circus performers, jazz musicians, dancers. The skill, spontaneity, and a certain sleight of hand involved in the activities of these popular artists and entertainers, with whom Picasso closely identified, offer a foil to his own feats as a draughtsman.

The son of a drawing instructor, Picasso began his artistic life with pencil and paper. Doodles and marginalia from his school books and an early sketchbook with portraits of family members reveal his already highly developed gift for characterization by age ten or eleven. His renderings after plaster casts and the nude model carried out at the School of Fine Arts in Barcelona in 1895–96 show that he had mastered the conventions of academic drawing by age fifteen. Throughout his seventy-five year career, which embraced painting, sculpture, printmaking, and ceramics, drawing remained central to Picasso's artistic endeavor. While he brought the same level of experimentation to his works on paper as to painting and sculpture, Picasso is also regarded (along with Matisse) as one of the last representatives of the great tradition in drawing, worthy of comparison with such masters as Ingres and Cézanne, whom he greatly

admired. His passion for drawing deepened over the course of his career, culminating in his last decades in large suites of works, such as the dazzling *Comédie Humaine* of 1953–54, a series of 158 drawings on the theme of the artist and model. Drawing served many purposes in his art, from notations of yet undeveloped ideas to preparatory studies for painting, to independent, full-fledged works. While Picasso's drawing was usually closely linked with his activity as a painter or sculptor, it sometimes took a separate course of its own.

Among the many methods (traditional and innovative) that Picasso employed in his works on paper, the pure line drawing occupies a significant place. "Drawing is no kidding," he once said. "It is something very grave and very mysterious that a simple line could represent a living being. Not only his image, but moreover, what he really is. What a marvel! Isn't it more surprising than all the prestidigitations and all the coincidences of the world?" As we know, there are no lines in nature: much of the appeal of the line drawing is its high level of abstractness, and its ability to convey a great deal of information with a minimum of means. Picasso made line drawings in many different styles, from his highly polished Ingresque portraits to the metamorphic figures of his Surrealist period.

In his one-line drawings, the technique remains the same (although in some, further embellishments have been added), but Picasso was able to achieve a remarkable variety of expression in this mode. This can be observed in a single set of works, like the harlequin group (pages 12–23), executed in pencil or pen and ink during the spring of 1918 in a curvilinear mode. The wily harlequin from the *commedia dell'arte* is a recurrent figure in Picasso's art, some-

times serving as an alter ego. Picasso's involvement in the theater as a set and costume designer for Serge Diaghilev's Ballets Russes after World War I, and his travel to Rome with the troupe in 1917, revived his early interest in the *commedia* of his Rose period. We sense Picasso's kinesthetic identification with the gliding and thrusting movements of his subject through the dynamism of his curving, looping lines. Starting, most likely, with the tricourne hat—harelquin's identifying marker—Picasso's tensile line moves as freely and gracefully as the performer. It can glide around the edge of the harlequin's large belly (page 13), suggesting weight and volume, while never actually enclosing the figure. Or (page 18), it can twirl around in loops, evoking harlequin's diamond-patterned suit, while the figure itself is represented only by implication—as pure energy. Or, the line can soar off at the end (page 15) well beyond the image, asserting its freedom from the burden of representation. Subtle differences in handling the line can be seen in drawings in different media, as in the harlequins on pages 12 and 13—the first done in wax crayon and the second in pen and ink, where the width of the stroke varies—or in a comparison of the elegant cock (page 48), in brush and watercolor, with the dog (page 27), drawn in pencil. Versions of the cock and the harlequin served as illustrations to Jean Cocteau's book on musical theory, *The Cock and the Harlequin,* published in 1918.

In his studies for the cover of Igor Stravinsky's score for Ragtime, from the same period as the harlequin suite, Picasso's line now seems to reverberate to sound, assuming a variety of patterns. The jagged, highly abstract quality of the drawing chosen for the cover (page 38) conveys the raw and vibrant tone of the banjo and violin and the

pulsating rhythm of ragtime music. In a charming caricature (page 57), Picasso depicts Stravinsky himself as a virtual embodiment of the music. In others, a softer, more fluid line, conveying a more melodic tone, is used, as in the banjo player and pianist (page 39), which is developed further in another drawing (page 45) to become a boldly flowing calligraphic pattern of lines of varying thickness. In this drawing, a small dog, depicted in a more representational manner, stands outside the swirling pattern that unites the musicians and their instruments, and yet is linked with the group with a wry stroke of the pen that can be read as a leash. Some of the drawings in this group seem to anticipate Picasso's great oil paintings of 1921, the two versions of *The Three Musicians*.

If the harlequin and *Ragtime* drawings represent Picasso's immediate response to movement and sound trans-lated into line, the drawings of dancers made in 1924 in connection with the set for the ballet, *Mercure* (pages 74–78) suggest that yet another force was at work here: his artisitic rivalry with Matisse, whose drawing he so greatly admired. Here, his friend is deliberately evoked in these playful pastiches.

The fantastic bathers (pages 54–56) made during the summer of 1928 at Dinard belong to one of Picasso's most prolific periods of graphic activity. During the late twenties and early thirties, when he was closely connected with the Surrealist movement, served as the wellspring of a new vocabulary of abstract organic form. In these metamorphic works, the line seems to take on a life of its own, submitting the female body to a series of bizarre transformations.

Picasso's delight in gesture, evident in many of his one-line works, gives way here to a more cerebral pleasure in formal invention.

The wizardry of Picasso's drawing is best expressed in his suite of images of the horse and its juggler/trainer (pages 66–73), carried out in pencil in 1920. These capture most effectively of all the showmanship, wit, and mastery of means integral to his one-liners in an elegant allegory of art. A single line creates the juggler (surrogate for the artist), balancing an object on his head, who cracks his whip (his pencil), sending up a long rope (the line) that touches the horse, who rears up in response (the artist's image), as the line moves on to encircle the whole scene in a circus ring with a doorway entrance (the frame). Picasso invites us to take a seat at the spectacle, and to share the exuberance, the risks, and the sheer magic of each act of creation.

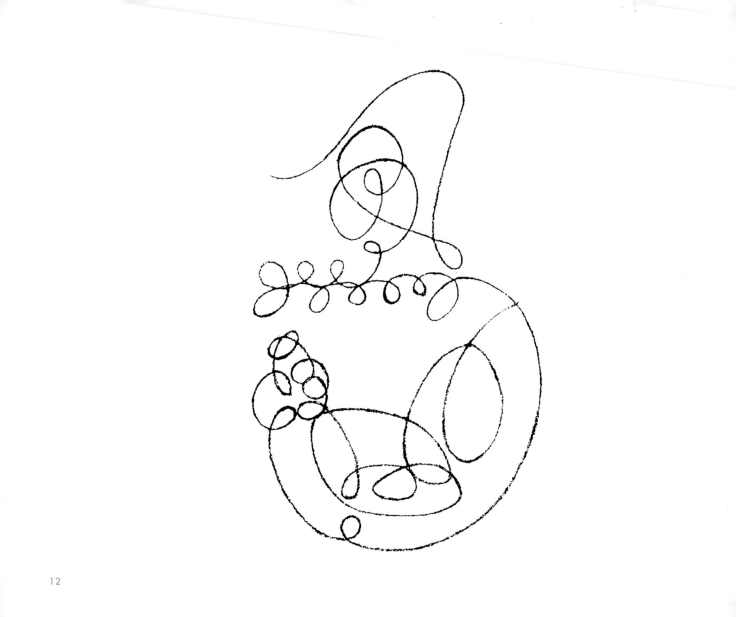

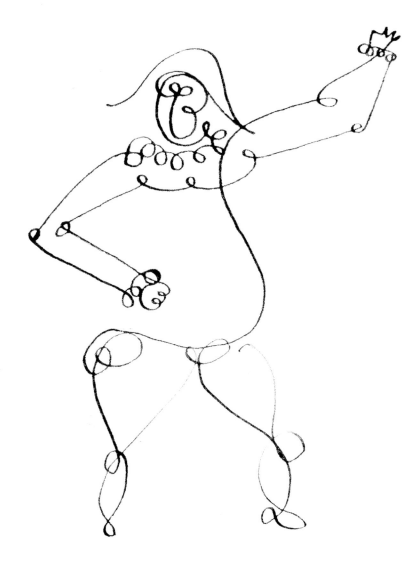

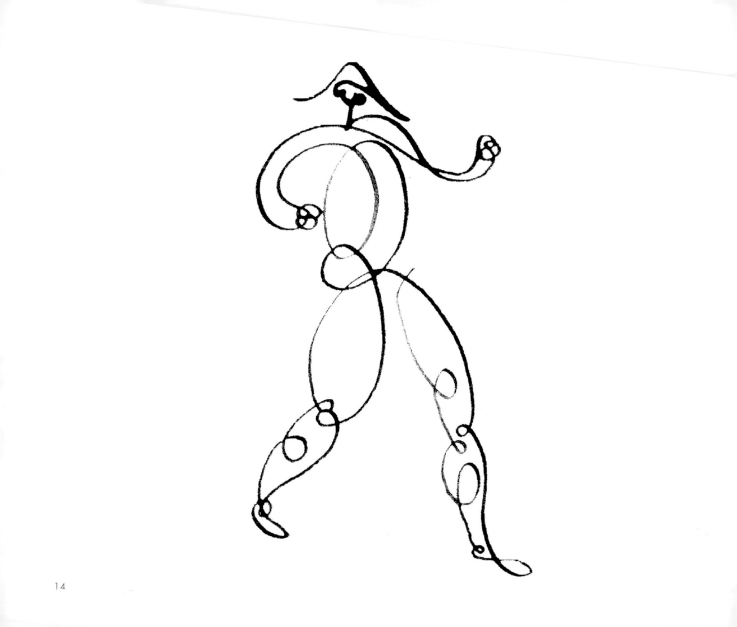

14

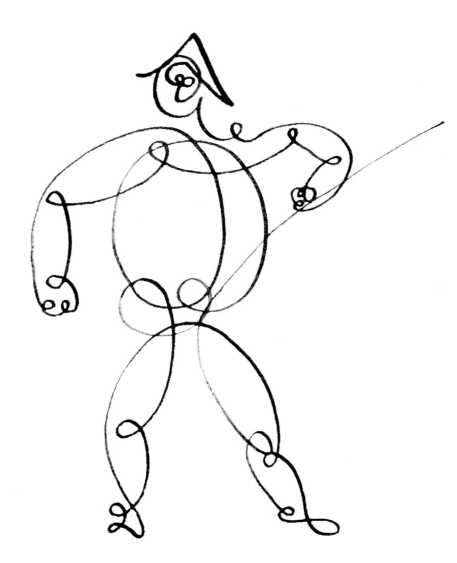

15

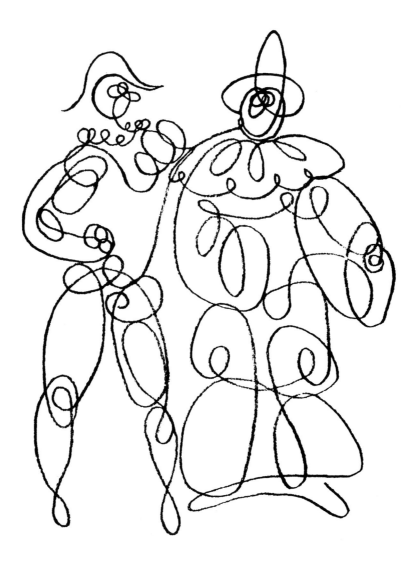

i 've reached the moment

when the movement

of my thought interests me more

than the thought itself.

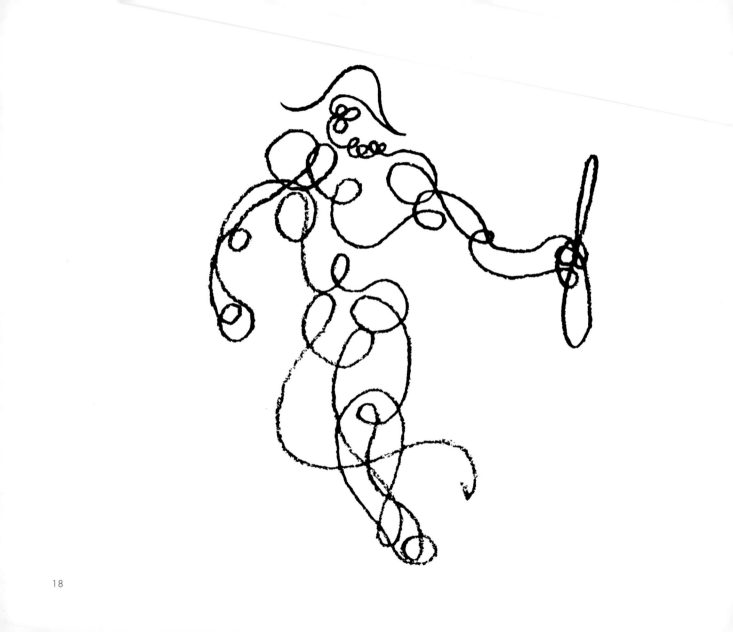

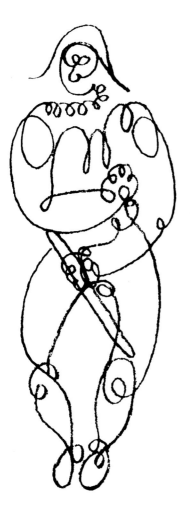

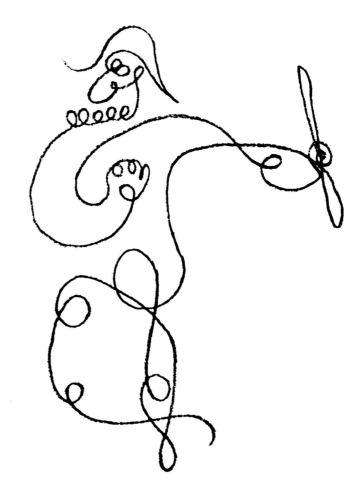

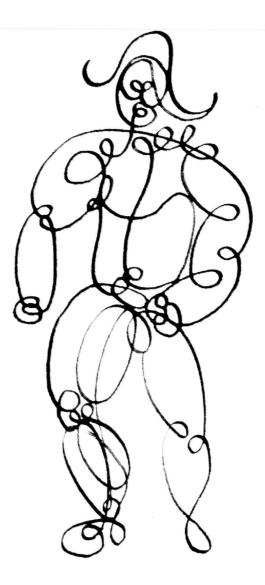

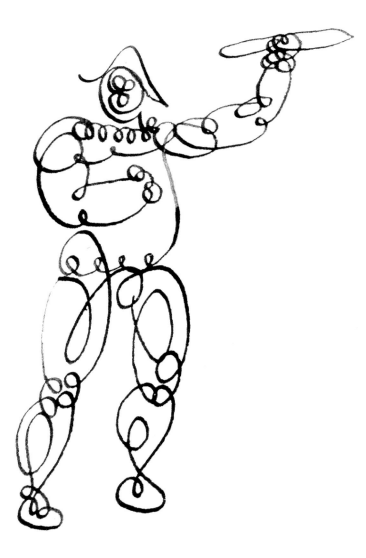

if you know exactly what you're going to do, what's the good of doing it?

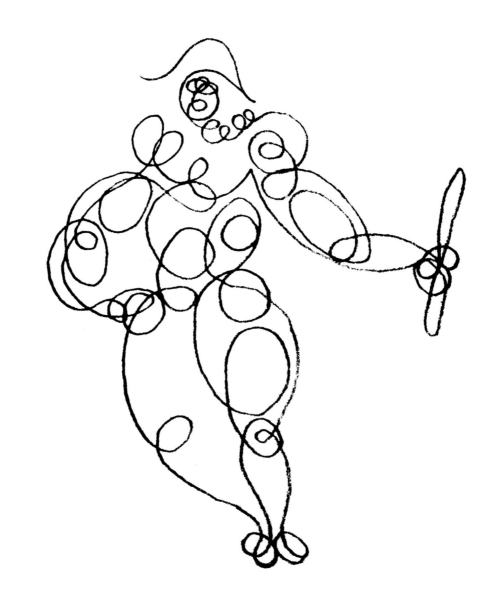

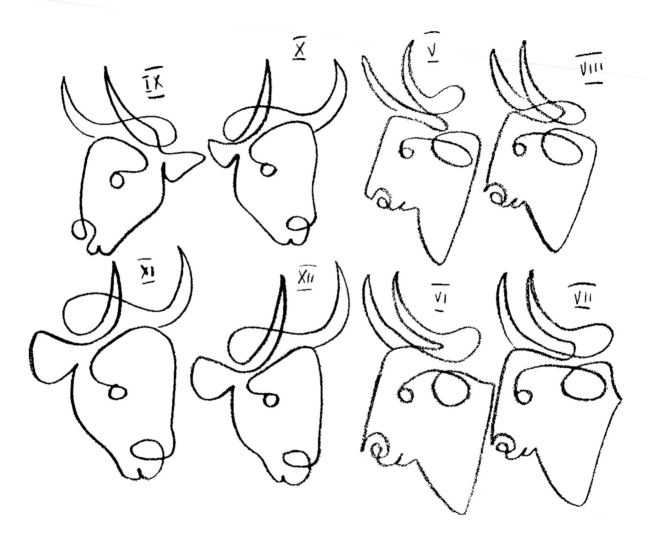

24

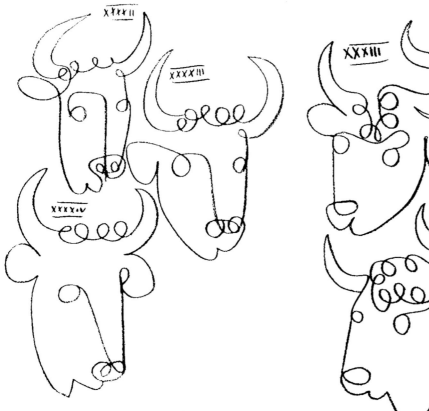
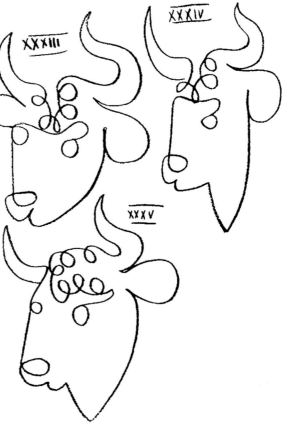

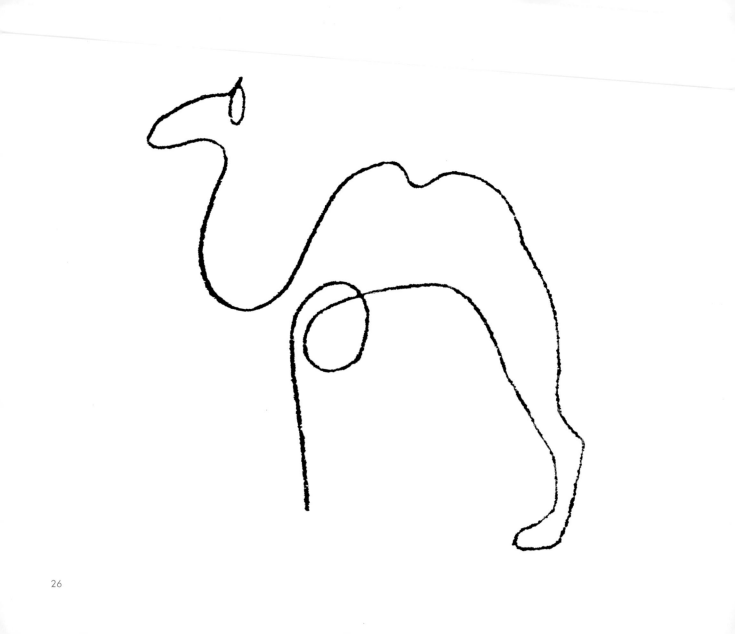

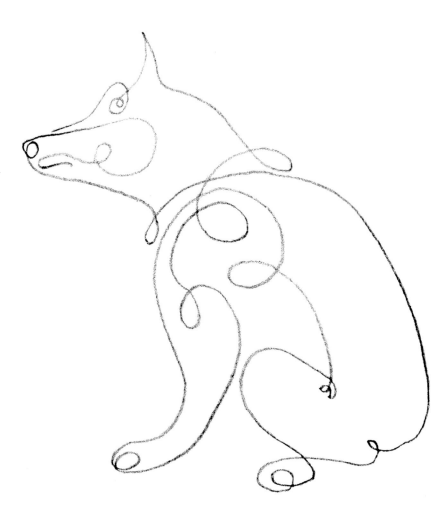

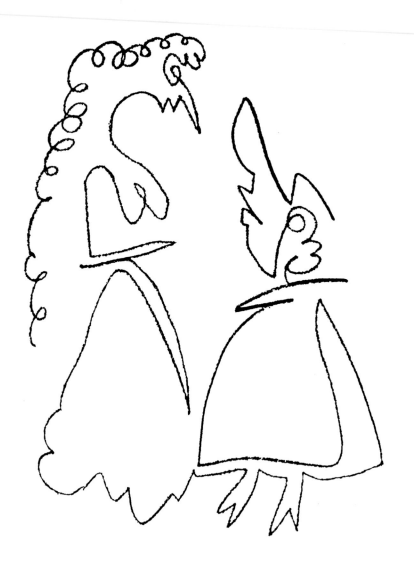

you have to begin drawing to know what you want to draw.

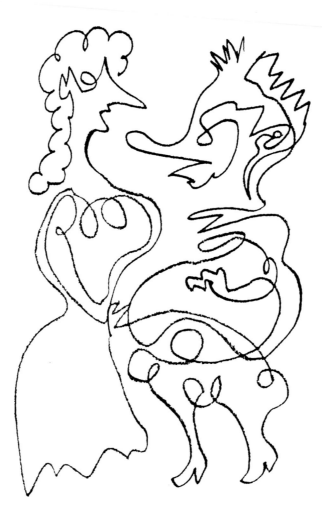

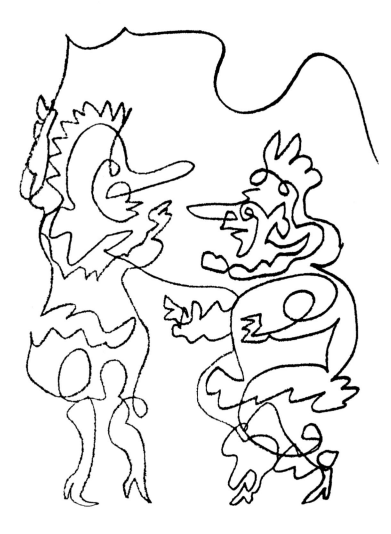

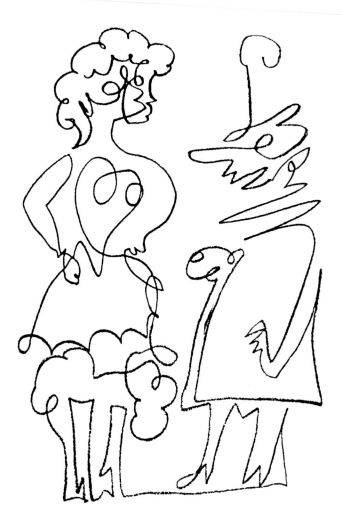

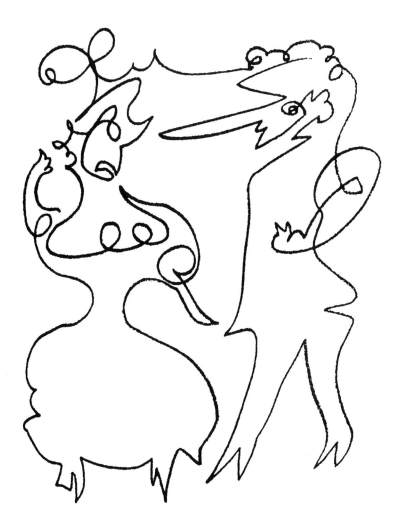

my old paintings

don't interest me anymore,

I'm much more curious about those

I haven't painted yet.

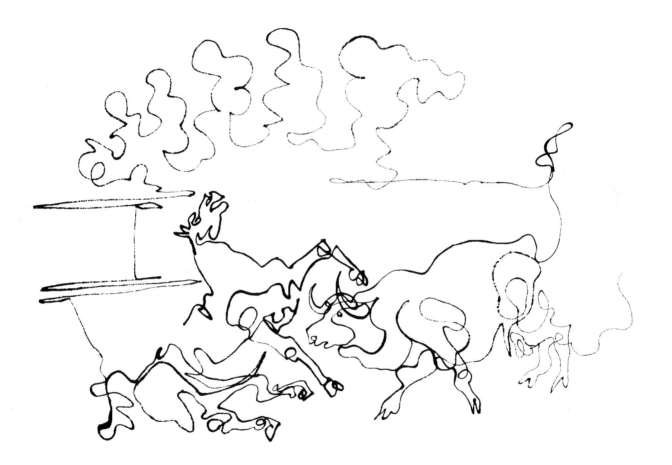

35

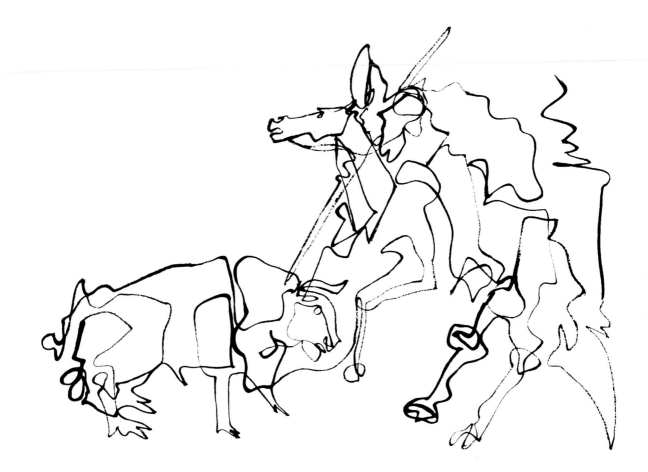

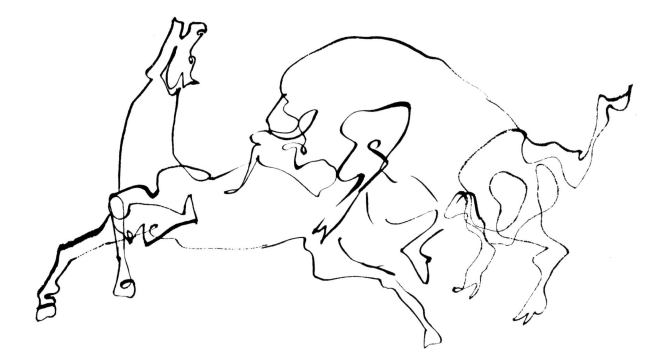

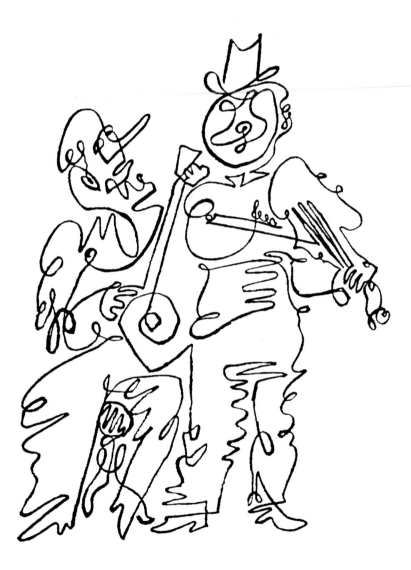

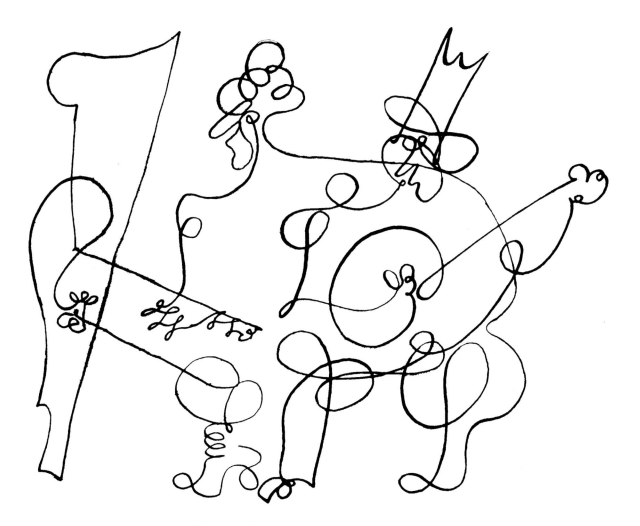

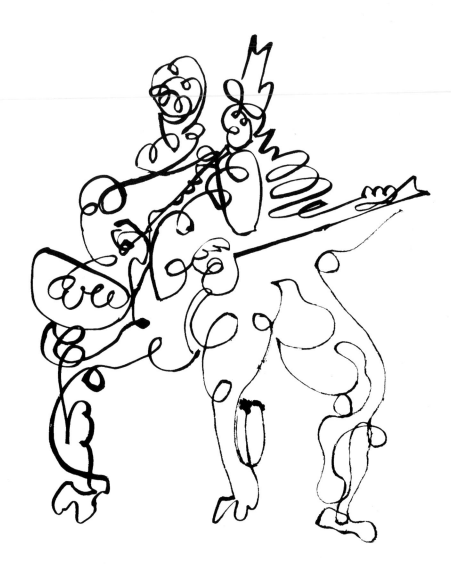

i have a horror of copying myself, but,

when someone shows me a portfolio of my

old drawings, I don't hesitate to take

whatever I need from them.

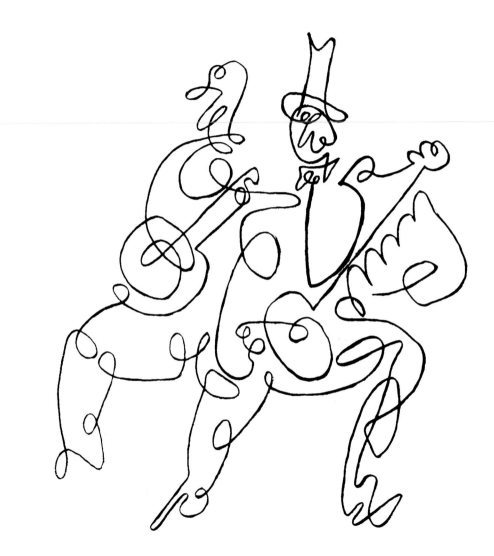

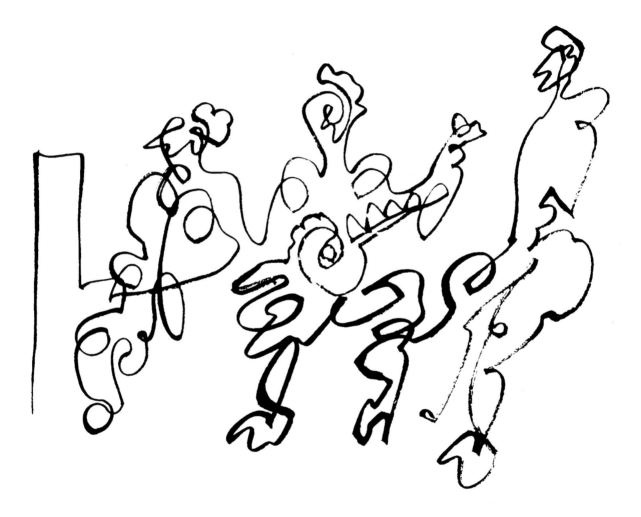

43

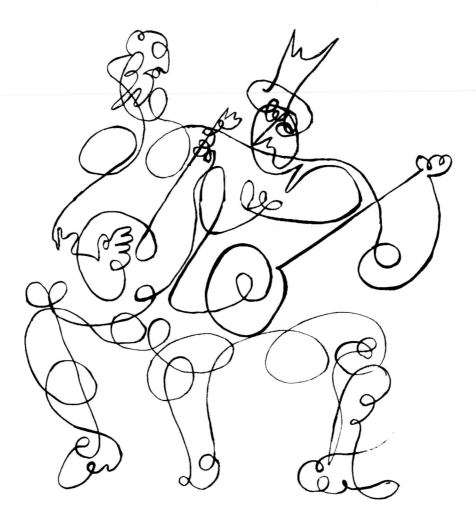

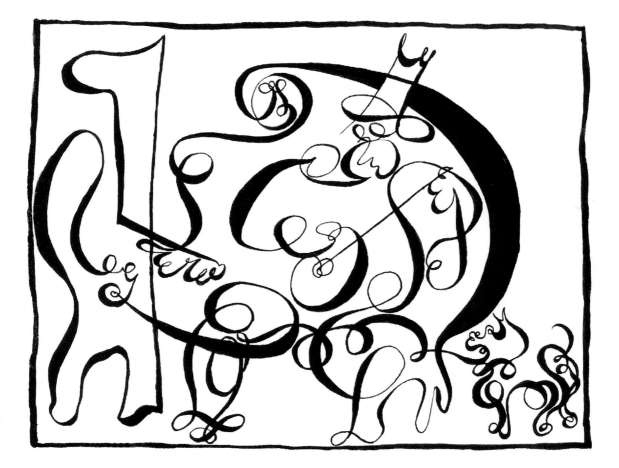

45

if there was a single truth,

you couldn't make a hundred paintings

of the same subject.

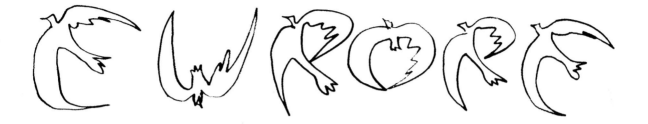

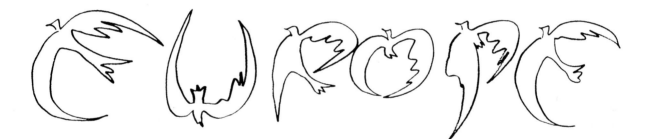

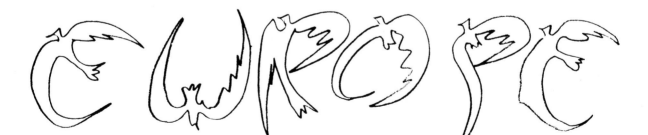

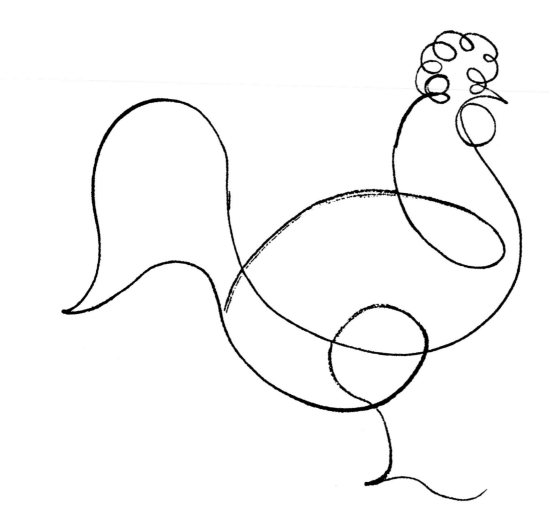

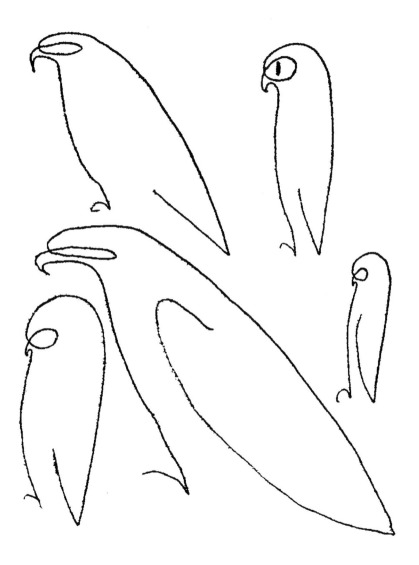

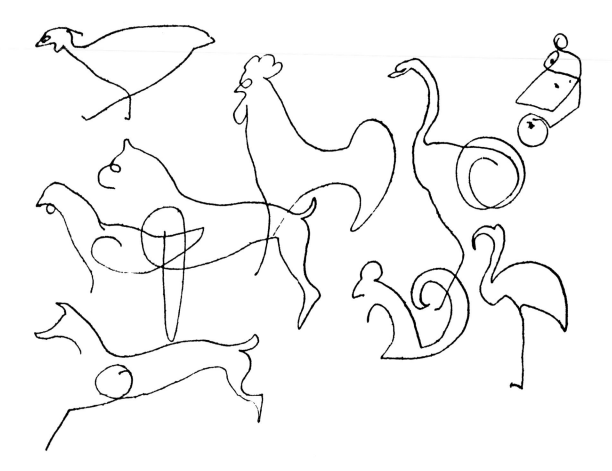

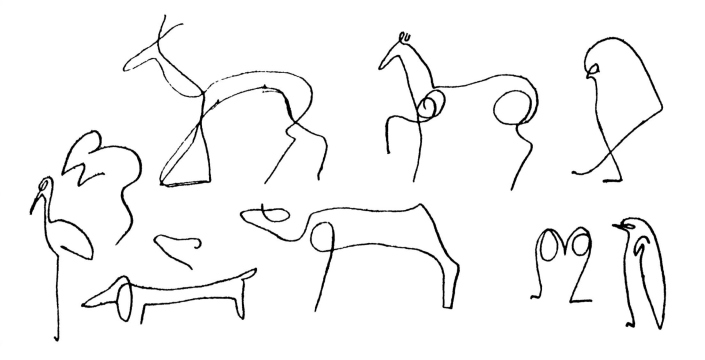

51

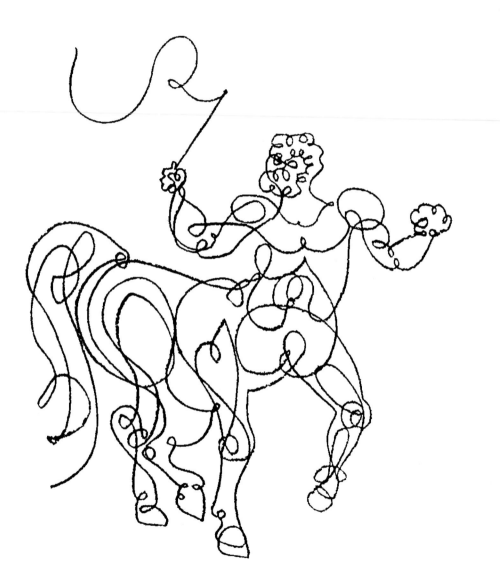

it is strange, in Paris I never

draw fauns, centaurs or mythical heroes like these,

they always seem to live in these parts.

Cannes

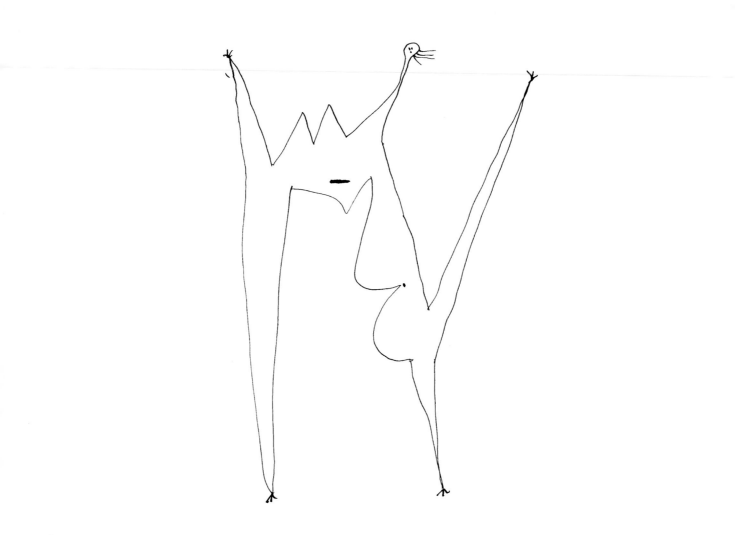

54

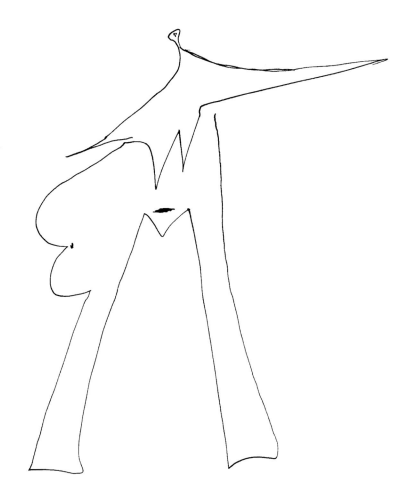

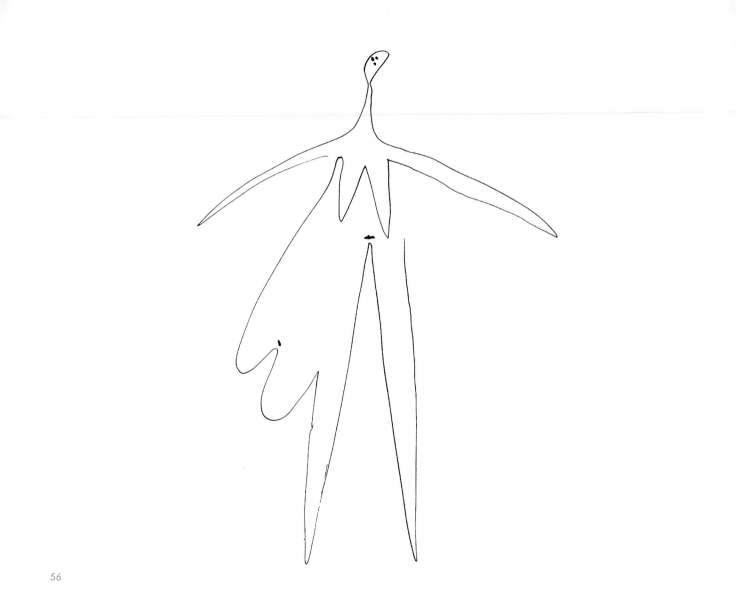

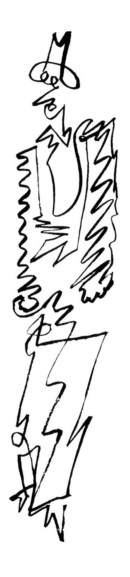

A picture has a life of its own like a living creature, and it undergoes the same changes we all undergo in daily life.

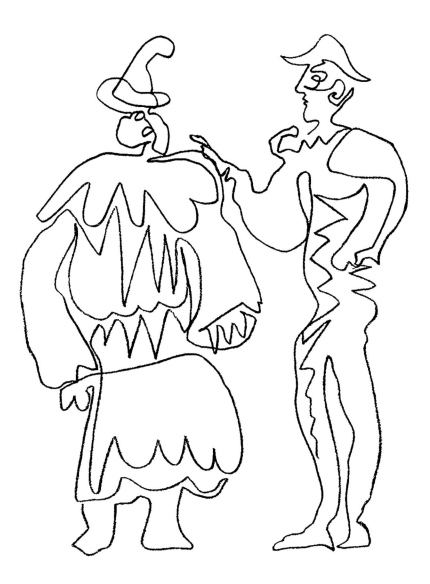

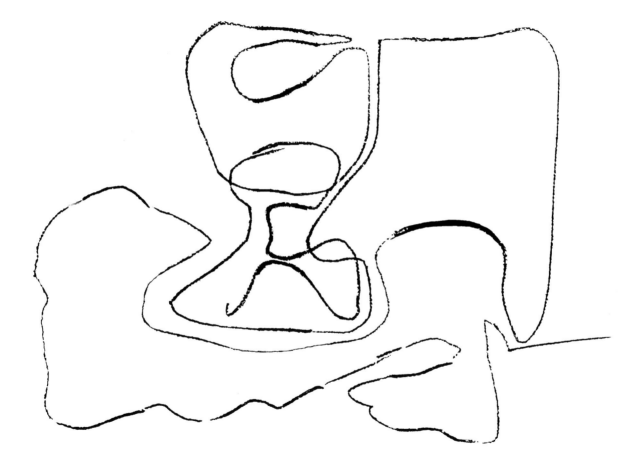

61

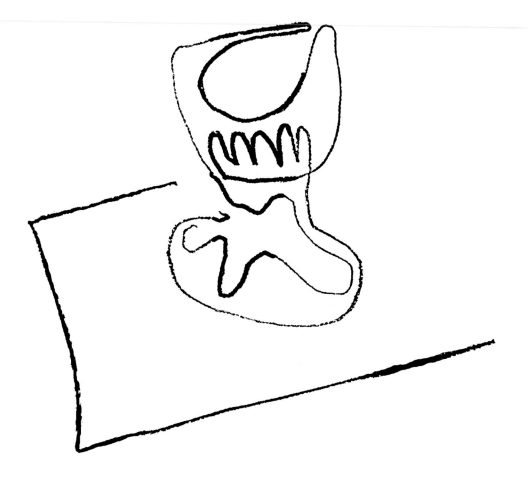

62

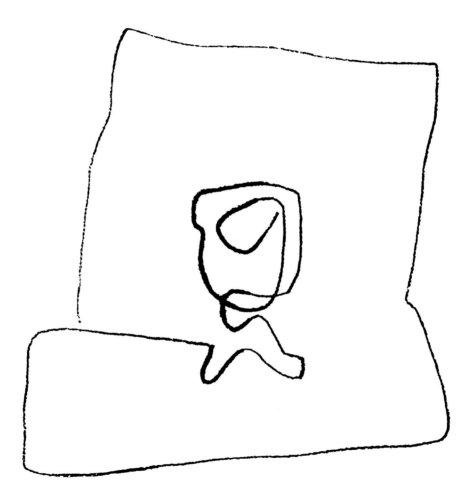

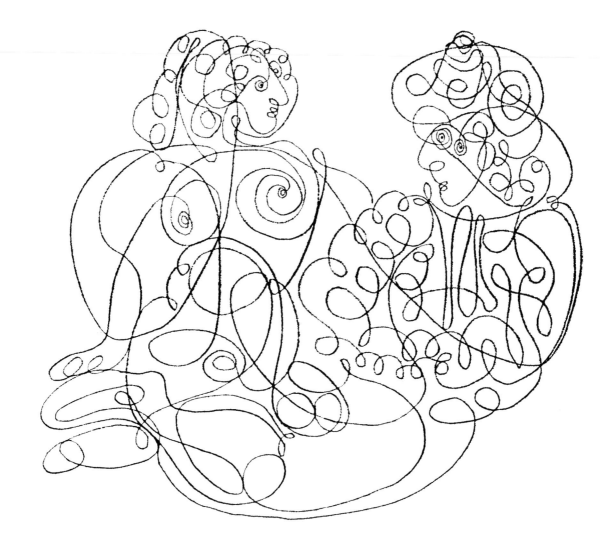

64

what one does

is what counts and not what one had the intention of doing.

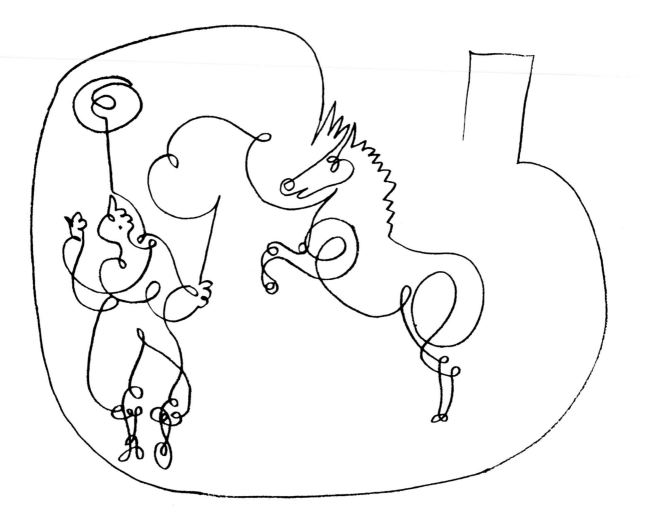

66

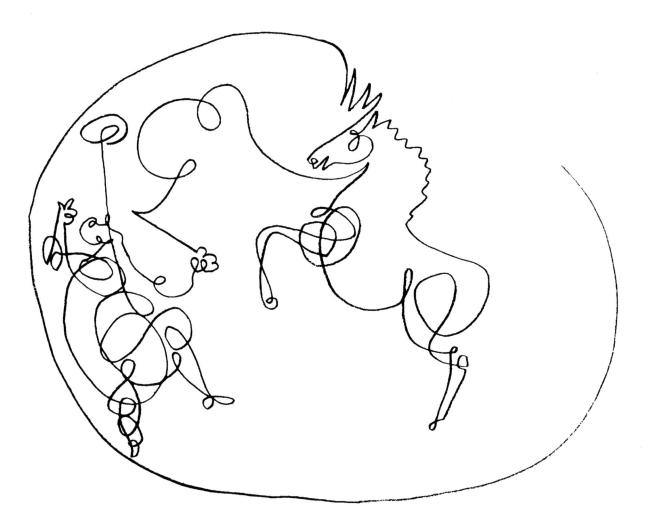

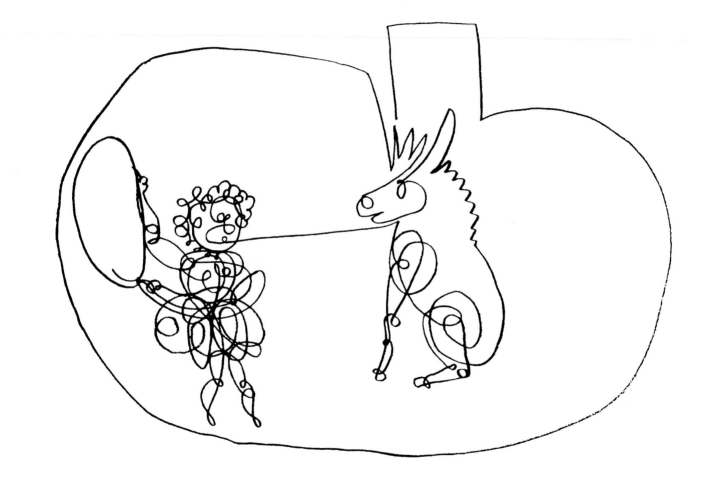

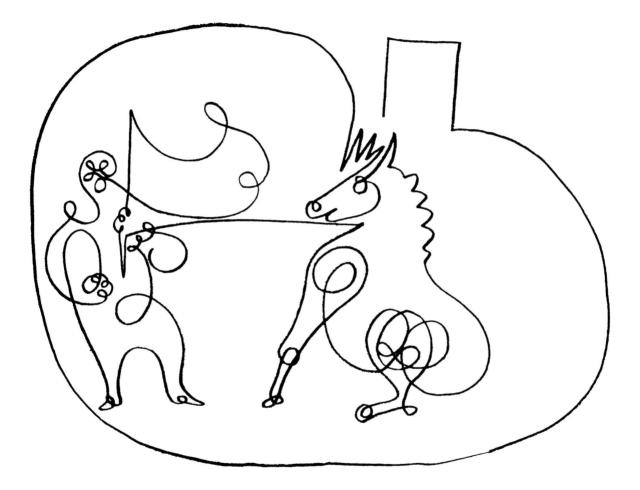

if a work of art

cannot live always in the present it must not

be considered at all.

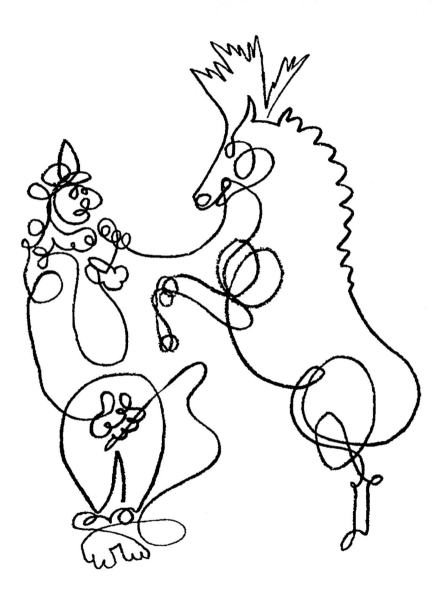

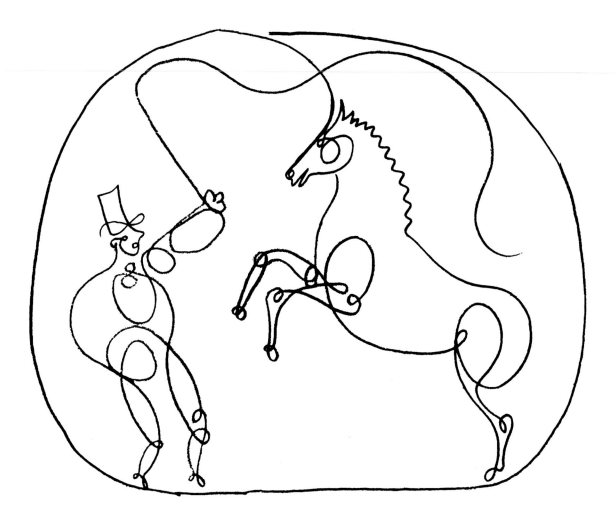

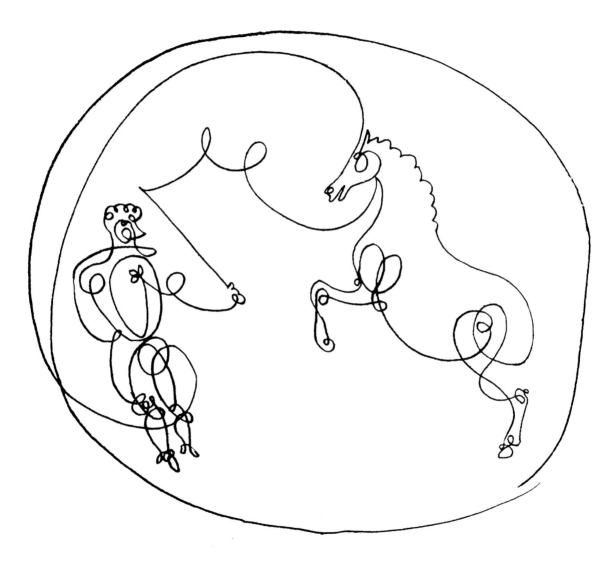

73

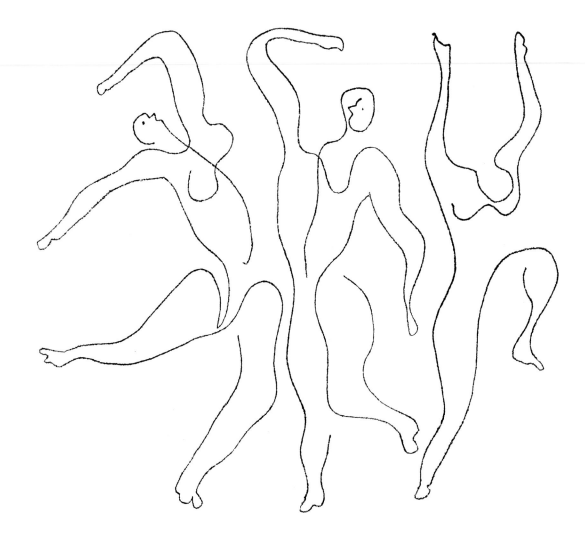

74

the fatigue of one's hand

as one draws is a perception

of time.

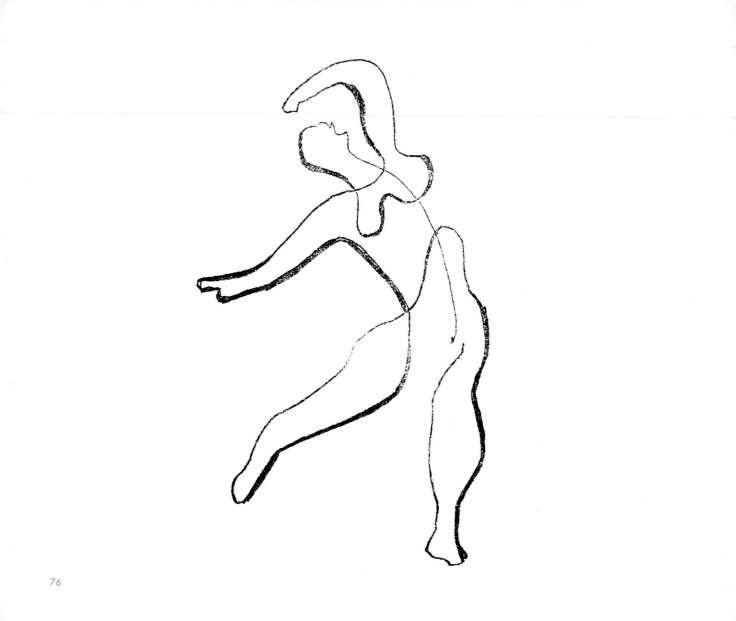

76

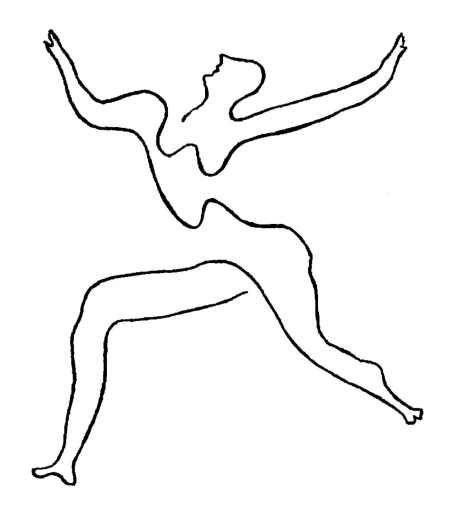

LIST OF DRAWINGS

END OF THE LINE

BOOK CONCEPT AND DESIGN BY DENNIS AND SUSAN FEIGENBAUM

THE TEXT WAS SET IN BODONI BOOK AND FUTURA

PRINTED AND BOUND BY TIEN WAH PRESS, SINGAPORE